Twenty to Make

Sugar Flowers

Lisa Slatter

Search Press

First published in Great Britain 2011

Search Press Limited
Wellwood, North Farm Road,
Tunbridge Wells, Kent TN2 3DR

Reprnted 2011

Text copyright © Lisa Slatter 2011

Photographs by Debbie Patterson at
Search Press Studios

Photographs and design copyright
© Search Press Ltd 2011

ISBN: 978-1-84448-625-0

Suppliers
If you have difficulty in obtaining any of the
materials and equipment mentioned in this book,
then please visit the Search Press website for
details of suppliers: www.searchpress.com

Printed in Malaysia

Dedication
*This book is dedicated to the following
special women who have enriched and
touched my life. To my dear friend Maggie,
for your loyal friendship and mutual love
of sugar flowers; to my wonderful Mum,
for your never-ending love and devotion;
and finally, to the memory of Rita Slatter,
Nan Thomas and Nan Crocker for the very
special times and fond family memories.*

Contents

Introduction

I attended my first sugar flowers class at night school when I was just nineteen years old and from that day forward I was hooked.

The flowers in this book have been produced with the beginner in mind, and are split between the unwired flowers on pages 8–25 and the wired flowers on pages 26–47. They are not, nor are they intended to be, botanically correct in their appearance. Rather, they are an artistic representation of the basics of making sugar flowers.

I hope that the projects I have produced in this book will inspire you to get creative and fill you with the same enthusiasm and passion for the craft as I was. In fact, that same enthusiasm is mine to this day!

Royal icing recipe
Royal icing has been used to stick some of the flowers on to plaques and to pipe some leaves, stems and the daffodil (see page 22). The consistency for piping sugar flowers needs to be stiff so that the petals and leaves hold their shapes.

- 1 egg white
- 250g (9oz) sifted icing sugar

Method
1 Lightly beat the egg whites in a bowl.

2 Slowly beat in the icing sugar; this can take between seven and ten minutes to achieve the right consistency.

3 When the icing looks glossy and forms firm peaks, it is ready to use.

4 When not in use, keep covered with plastic wrap and store in an airtight container.

Opposite:
A selection of the fantastic flowers that you can make following the instructions in this book.

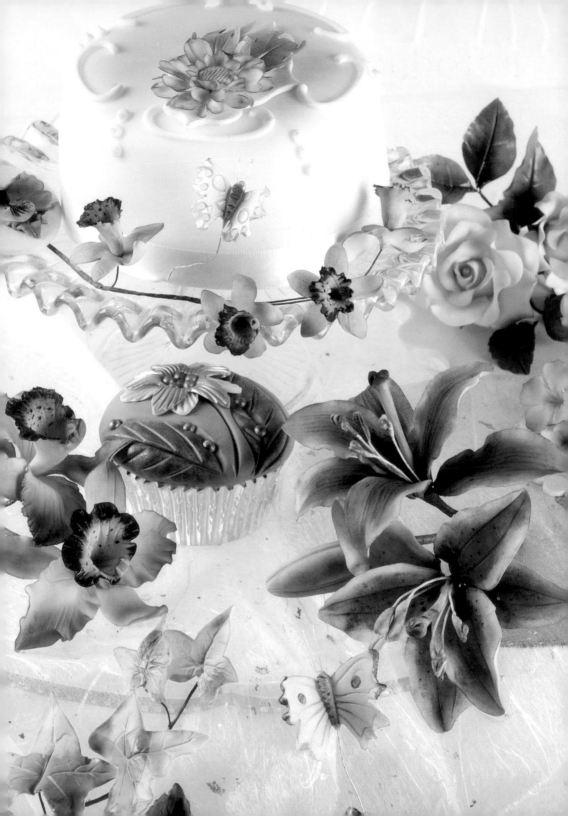

Materials and equipment

Basic materials

These basic materials are used in all of the projects, so you should keep them handy.

Gum paste is used to make sugar flowers. It can be rolled extremely thinly and dries hard. It is also known as flower paste or petal paste, and is readily available from all good sugarcraft and cake shops or easy to make yourself if you have a heavy-duty mixer.

White fat is used to stop paste sticking. You might find it called Trex or Crisco.

Cornflour is used to stop paste sticking. Use it sparingly as it will dry paste out too much if you are not careful. It is also called cornstarch.

Sugar glue is made by dissolving a small piece of gum paste in a little hot water. It is also available ready made from all good sugarcraft shops. Water may be used as an alternative but will not give such a strong bond.

Sugarpaste is used for filling containers in which to arrange flowers.

Modelling paste is an equal mix of gum paste and sugarpaste. It is used to make plaques.

Basic tools

Similarly, these are the tools that you will use in nearly all of the projects.

Small non-stick rolling-out board This surface is used for rolling out gum paste on to.

23cm (9in) non-stick rolling pin This is used for rolling gum paste thinly.

Non-slip mat Place one of these underneath your rolling-out board to prevent it from slipping.

Mexican foam balling pad Use this when softening, cupping and shaping the edges of petals. It is not essential as you could use the palm of your hand instead, but these pads are ideal for people with hot hands.

Good quality flower and leaf cutters These are available in a vast array of shapes and sizes, in metal or plastic. Aim for a broad selection.

Selection of leaf veiners Leaf veiners are an integral part of plunger cutters; just cut out the leaf shape, then push the plunger down on to the surface to vein the front of the leaf. They are also available separately, in which case they are usually double-sided and made from food-

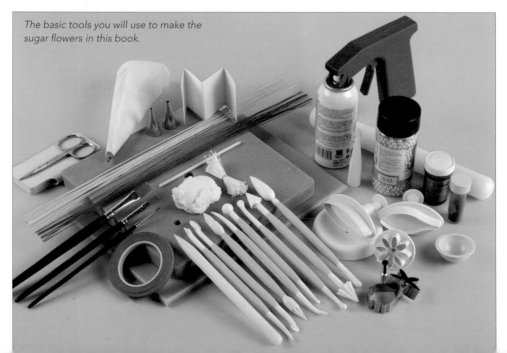

The basic tools you will use to make the sugar flowers in this book.

grade silicone. The leaf is placed inside and the veiners are squashed together to create a veined surface on the front and back of the leaf.

Stem tape This is a stretchy self-sticking paper tape used to cover wires, attach stamens to the ends of wires and to bind flowers together into sprays, posies and arrangements. It can also be used to make stamens.

Wires I use paper-covered wire, the thickness of which is measured in gauge (g): 18g being the thickest and 33g being the thinnest. Choose a gauge of wire to suit the weight and size of your flower.

Food colours There are different ways to colour your flowers. Paste food colours can be kneaded into gum paste to colour it or mixed with white alcohol and used to paint with; and powdered food colours, which can be brushed on to petals to colour them or mixed with white alcohol to paint.

Paintbrushes A variety of brushes is very useful. I use a round size 4 to stick items together, a fine size 2/0 round for painting fine detail and a 12mm (½in) flat for dusting powdered food colours on to the flowers.

Dresden tool This is otherwise known as a flower/leaf veining tool, and it is used to vein and flute leaves and petals.

Ball tool This is used to push or rub into the centre of petals, to cup and shape them.

Bone tool Rub this around the edge of petals to thin, soften, flute and frill them.

Bulbous cone tool Push this into the centre of a flower to open up the centre.

Tapered 5 and serrated cone tools Push these into the centre of a flower to mark a star shape or marking guidelines.

Mini modelling tools Cocktail sticks and toothpicks are used for frilling, rolling and shaping your gum paste.

Small pair of scissors These are used to cut petals, mark buds and calyces.

Tape cutter This cuts stem tape down into thinner widths for ease of use.

Craft knife A sharp blade is essential in order to ensure safe cutting.

Small wire cutters These are used for cutting wires to the correct length.

Small long-nosed pliers Bending wires in place is much easier and safer with this tool.

Cake dummy You can push your wired flowers into this to dry.

Kitchen towel This is used when dusting and drying flowers and leaves.

Stamens Tiny, round, dull-headed stamens are used in preparing some of the floral centres.

Piping bag and tubes These are used for piping leaves, stems, petals and other parts.

White alcohol Mix this with food colours for painting. Alcohol evaporates quickly, ensuring no surface damage is done to the icing. You can use dipping solution, rejuvenator spirit, lemon extract or clear vanilla essence instead.

Confectioners' glaze This is available either bottled or as an aerosol spray, and it is used to add a glossy finish to leaves and berries.

Lustre spray Pearl, gold, bronze, pink – spray food colour with sparkle.

Ribbon Use this to back sprays and fill in gaps.

Cupcakes Vase for appliqué flowers.

Cupcake wrappers These are lacy wrappers for cupcakes. A style called chocolate swirl is used in the Fantasy Floral Cupcake project (see pages 24–25).

The majority of the products used in this book are manufactured by Knightsbridge PME Ltd. All PME products are available from good sugarcraft and cook shops around the world.

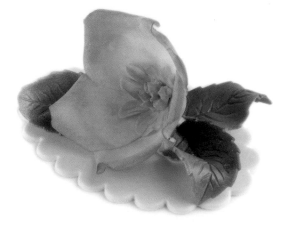

Gladioli

Materials:

Gum paste: white, green
Paste food colour: green
Powdered food colour: pale lemon, moss green
Royal icing: green

Tools:

Dresden tool
Mini cutting wheel
Paintbrush: 12mm (½in) flat
Oval plaque cutter: 70mm (2¾in)
Piping bag and leaf tube: ST52
Pearl lustre spray with spray gun attachment

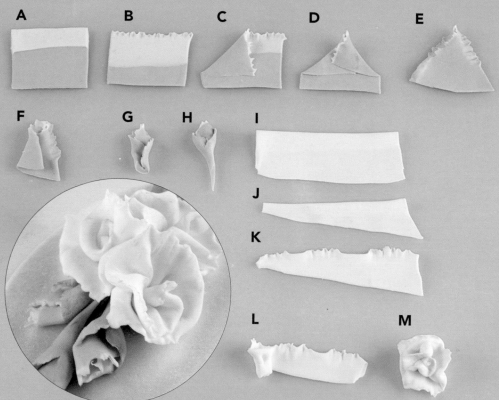

A **B** **C** **D** **E**

F **G** **H** **I**

J

K

L **M**

Instructions:

Leaves

1 Roll out some gum paste in both green and white thinly. Cut a 5 x 3cm (2 x 1¼in) green oblong and a 1 x 5cm (⅜ x 2in) white strip using a cutting wheel. Dampen the white strip with water and stick it on to the green piece, matching up the straight edges.

2 Use the small rolling pin to thin and seal the pieces together (A). Texture the white edge by repeatedly pulling the soft end of the Dresden tool over the edge (B); use white fat to stop the paste from sticking.

3 Diagonally fold the top left-hand corner of paste across, to form a triangle (C).

4 Repeat step 3 for the right-hand corner (D). Roll over the bottom seam with a small rolling pin to secure.

5 Texture the top edges using a veining tool, as previously described in step 2 (E).

6 Now vertically fold the bottom left-hand corner over towards the middle (F).

7 Fold the bottom bottom right-hand corner over towards the middle (G).

8 Roll the base of the leaf between your fingers to taper and make a stem (H). Cut off excess paste with the cutting wheel.

Flowers

9 Roll out a piece of white gum paste as before. Gently fold in half, then place your rolling pin on the paste just below the folded edge and roll it towards you, sealing the bottom part of the paste together and leaving a small hollow tube running along the top edge (I).

10 With the hollow tube to the top edge, cut the paste into a long tapered triangle shape using a mini cutting wheel (J).

11 Texture the top edge at random using the same technique as for the leaves (K).

12 At the tapered end, begin to roll up the shape, pinching and pleating the bottom edge together as you do so (L). If necessary, secure with water. Once dry, colour as required using powdered food colour and the 12mm (½in) flat brush (M).

13 Use green royal icing to secure the flowers on an oval plaque sprayed with pearl lustre. Pipe the flower stems with green royal icing using a leaf tube. Place the tip of the tube at the base of the flowers at a 45-degree angle, with the deep 'V' of the tube facing upwards. Gently squeeze the piping bag to release the icing as you slowly pull the bag towards you. Release the squeeze on the bag and scrape the end of the tube against the surface of the plaque to finish the stem of icing.

Peach Gladioli
Use peach-coloured gum paste to create these fabric-effect flowers.

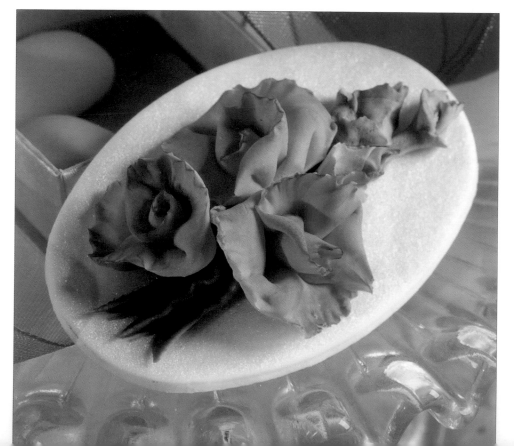

Spring Blossom

Materials:

Gum paste: white, pink
Paste food colour: gooseberry green, pink
Powdered food colour: rose pink
Royal icing: gooseberry green

Tools:

Extra large blossom plunger: 25mm (1in)
Large blossom plunger: 13mm (½in)
Paintbrush: 12mm (½in) flat
Circle plaque cutter: 45mm (1¾in)
Food bag
Piping bag and leaf tube: ST52
Pearl lustre spray with spray gun attachment
Cocktail stick
Ball tool and Mexican foam balling pad

A B C D

E F G

Instructions:

Flowers

1 On a non-stick surface, roll out some white gum paste quite thinly. Cut one five-petal blossom shape using the extra large plunger cutter blossom (A). Place it into a food bag to stop it from drying out.

2 Roll out a little pink gum paste quite thinly, then cut another blossom, this time using the large blossom cutter (B).

3 Take the larger white blossom and place the smaller pink blossom on top and gently squash them together (C).

4 Dust your non-stick surface with cornflour and lay the blossom on top. Lay a cocktail stick down the centre of one of the petals and roll it from side to side to widen, thin and frill the petal (D).

5 Repeat step 4 for each of the remaining four petals (E).

6 Hold the blossom and lightly push the end of a ball tool into the centre of the blossom, to cup up, then use your fingers to pinch and scrunch the sides of the flower together, pinching at the back of the blossom to secure.

Leave to dry on scrunched-up kitchen towel. Once dry, use a flat paintbrush to dust the edges of the petals with some rose pink powdered food colour (F).

7 Buds and smaller flowers can be achieved by pinching the paste in tightly at a higher level when performing step 6 (G). For some arrangements it will be necessary to snip the long back of the flower away with a pair of scissors.

Leaves

8 Use green royal icing to secure the flowers on a small round and wavy edged plaque sprayed with pearl lustre. Pipe leaves with green royal icing and a leaf tube. Insert the tube at a 45-degree angle in between the flowers with the deep 'V' of the tube facing to the sides. Touch the surface of the plaque with the piping tube and while holding it in place gently squeeze the bag to release the icing. Whilst still squeezing, gently pull the piping bag towards you and when the leaf is large enough, stop squeezing and pull the tube quickly towards you to break the stem of icing and form the leaf tip.

Pink Blossom
Swapping the colour combination and using a wavy-edged plaque cutter gives a different effect, and this looks just as at home on a cupcake as a gift box.

Viola

Materials:

Gum paste: white

Paste food colour: black

White alcohol

Powdered food colour: yellow,
 purple, orange

Royal icing: gooseberry green

Tools:

Small five-petal blossom cutter:
 30mm (1¼in)

Large oval plaque cutter:
 70mm (2¾in)

Ball tool

Paintbrushes: size 2/0 round,
 12mm (½in) flat

Piping bag and leaf tube: ST52

Mini modelling tool

Mexican foam balling pad

Pearl lustre spray with spray
 gun attachment

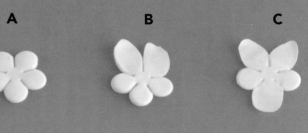

A B C

D E F

Instructions:

Flowers

1 On a non-stick surface, roll out some white gum paste quite thinly. Cut one five-petal blossom shape using the five-petal blossom cutter (A).

2 Lay a mini modelling tool horizontally across the base of one of the top petals and roll across the surface towards the top of the petal to elongate. Now place the same tool vertically down the centre of the petal with the tip of the tool at the centre of the flower and roll from side to side to widen the petal (B). Repeat for the second top petal.

3 Repeat the process at step 2 for the bottom petal (the one directly opposite the top two petals), but this time lengthen a little and widen a lot more (C).

G

4 The two side petals are just widened, not lengthened, as described above in step 2. Place the flower on to a Mexican foam balling pad and rub around the outside edge of each petal with a ball tool to soften. Push the ball tool into the centre of each petal to cup (D).

5 Pull the petals into shape with your fingers, overlap the top two petals slightly, pull the side petals forward and the bottom petal forward, pinching it to a soft point at the base. Leave on scrunched-up kitchen paper to dry. To colour, use the flat brush with some yellow powdered food colour. Pull the colour over the outer edge of the petal in towards the centre, continuing over the bottom petal and across the bottom half of the two side petals (E).

6 Brush some purple powdered food colour over the top two petals and blend across the top half of the side petals (F). Mix some black paste food colour with a little white alcohol and use the size 2/0 paintbrush to paint some lines on to the bottom and side petals.

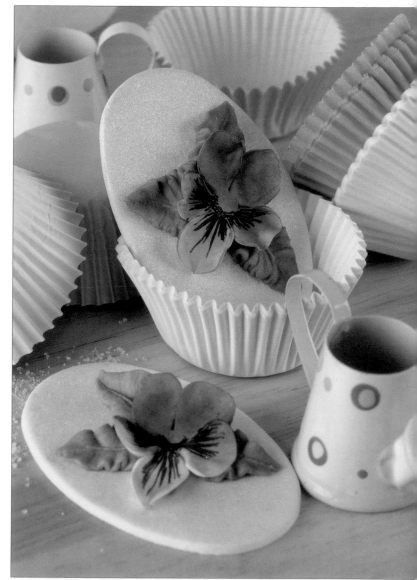

Leaves

7 With royal icing, arrange on an oval plaque, sprayed with pearl lustre spray. Pipe leaves with green royal icing and the leaf tube, ensuring the deep 'V' of the piping tube faces the sides (G). See step 8 on page 11 for full instructions for piping the leaves.

Viola Variations

These are great little flowers with which to decorate cupcakes. Use different colour combinations to vary the look.

Daisy

Materials:

Gum paste: white, green, yellow

Powdered food colour: pink

Royal icing: white

Tools:

Daisy marguerite plunger cutters: 35mm (1⅜in) and 20mm (¾in)

Daisy leaf cutter

Creative plaque embossing cutter: 75mm (3in)

Sieve

Mexican foam modelling pad

Dresden tool,

Paintbrush: 12mm (½in) flat,

Pearl lustre spray with spray gun attachment

A **B** **C** **D** **E**

F **G** **H** **I** **J**

K **L** **M**

Instructions:

Flowers

1 On a non-stick surface, roll out some white gum paste quite thinly. Cut out a daisy shape using the largest cutter (A).

2 Use a craft knife or mini cutting wheel to make a central cut along each petal to divide it into two (B).

3 Lay a mini modelling tool vertically down the centre of one petal, with the tip of the tool at the centre of the flower, then roll from side to side to widen and thin the petal. Ensure you use cornflour on your board and tool to stop the paste from sticking (C).

4 Continue to roll each petal in turn until you have completed the whole flower (D).

5 Prepare another large daisy shape in the same way as above then paint a little sugar glue on to the centre of one of the large daisy shapes and stick the other on top (E).

6 Cut out a small daisy shape and divide each of the petals in half (F).

7 Roll each petal from side to side to widen and thin (G).

8 Roll a pea-sized ball of yellow gum paste (H) then push the ball against the surface of a sieve to flatten into a textured disc (I).

9 Paint the centre of the small prepared daisy shape with sugar glue and stick the yellow textured disc into the centre. Wrap the petals up around the sides of the disc, using a little sugar glue to secure if necessary (J).

10 Stick the centre into the middle of the layered larger petals (K).

Leaves
11 From green gum paste, cut out two daisy leaves, pull a vein down the centre and several more from the central vein out to the outer edge using a dresden tool (L).

12 Place on a Mexican foam modelling pad and soften the edges by rubbing a ball or bone tool all around the edges (M).

13 Once dry, use the flat brush to dust the edges of the petal with a little pink powdered food colour, spray the leaves with pearl lustre colour and arrange on a plaque with a little royal icing (see detail opposite).

Peach Daisy
For an alternative look try dusting the edges of the petals with peach powdered food colour.

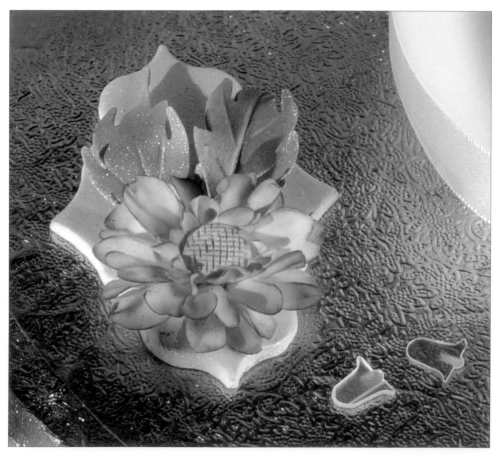

Hydrangea

Materials:

Gum paste: white

Powdered food colour: pink, blue

Royal icing: white, green

Tools:

Small daphne cutter

Round wavy-edged plaque cutter: 100mm (4in)

Half ball mould: 32mm (1¼in)

Paintbrush: 12mm (½in) flat

Piping bag, leaf tube: ST52 and rope tube: ST43

Ball tool

Pearl lustre spray with spray gun attachment

Mini modelling tool

Mexican foam balling pad

A **B** **C**

D **E** **F**

16

Instructions:

Flowers

1 Roll out some white gum paste quite thinly on a non-stick surface. Cut out a flower with a small daphne cutter (A).

2 Lay a mini modelling tool vertically down the centre of one petal, with the tip of the tool at the centre of the flower, then roll it from side to side to widen and thin the petal. Repeat for the remaining three petals (B).

3 Place the flower on to a Mexican foam modelling pad and push the ball tool into the centre of the flower to cup (C). Make several more and place inside a plastic bag to keep them soft (this will enable the flowers to fit together easily without breakage).

4 Dust the inside of the half ball mould with cornflour. Push a ball of modelling paste into the ball mould so that it fills it completely. Cut any excess paste away so that the paste is level with the edge of the mould, then remove the piece from the mould (D).

5 Use sugar glue to stick the first soft flower on to the domed centre of the half ball, pushing it into place with a ball tool (E).

6 Stick the remaining soft flowers around the half ball in the same way, and pipe a centre in each with white royal icing and the rope tube (F). Once dry, pull some blue powdered food colour softly across the edge of the petals with a flat brush to add some colour (see detail opposite). Make a second flower in the same way, but colour this with pink rather than blue.

Leaves

7 With royal icing, arrange on a round wavy-edged plaque, sprayed with pearl lustre spray. Pipe stems and leaves with green royal icing and the leaf tube, ensuring the deep 'V' of the piping tube faces the side when piping leaves and to the top when piping the stems. See step 13 on page 9 for full instructions for piping the stems, step 8 on page 11 for instructions for the leaves.

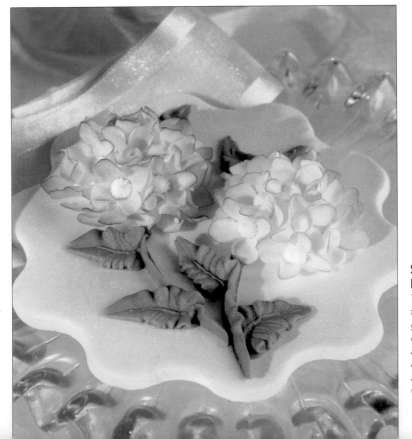

Summer Hydrangea

These pretty flower heads look great on top of cupcakes or used as a stylish side design for a stacked wedding cake.

Gerbera

Materials:

Gum paste: pink, yellow, green

Powdered food colour: yellow, green, pink

Royal icing: white

Tools:

Sunflower/gerbera plunger cutter: 70mm (2¾in)

Daisy marguerite plunger cutter: 30mm (1¼in) and 27mm (1in)

Large ivy leaf plunger cutter: 43mm (1¾in)

Mini quilting tool

Flower former

Round plaque cutter: 100mm (4in)

Mexican foam balling pad

Sieve

Paintbrush: 12mm (½in) flat

Mini modelling tool

Ball tool

Instructions:

1 Cut out a daisy shape using the 27mm (1¼in) daisy marguerite cutter (A).

2 Use a craft knife to make a central cut along each petal to divide it into two (B).

3 Place a mini modelling tool vertically on the petal, with the tip of the tool at the centre of the flower. Roll the tool from side to side to widen and thin the petals. Place the piece on to a Mexican foam modelling pad and pull the ball tool from the tip to the base of the petals to cup them (C). Ensure you use cornflour on your board and tool to stop the paste from sticking.

18

4 Roll a pea-sized ball of yellow gum paste (D).

5 Push the yellow ball of paste against the surface of the sieve to flatten it into a textured disc (E).

6 Paint the centre of the medium prepared daisy shape with sugar glue and stick the yellow textured disc into the centre. Wrap the petals up around the sides of the disc (F). Use a little extra sugar glue to secure if necessary.

7 Prepare two more sets of petals repeating steps 1–3 above (G and H), this time using the slightly larger 30mm (1¼in) cutter. With sugar glue, stick these two sets of petals one on top of the other so that the petals interleave, then stick the prepared yellow centre into the centre of the petals (I).

8 On a non-stick surface, roll out some pink gum paste quite thinly. Cut a large daisy shape out of the paste using the sunflower/gerbera plunger cutter (G).

9 Place the flower on the foam balling pad, then rub a ball softly around the tips of each petal to soften and shape. Flip the flower over

and pull the ball tool from tip to base of petals to cup slightly (H).

10 Prepare a second flower in the same way. With a little sugar glue, stick the two large flowers together, placing one on top of the other and positioning the petals of the second layer so that they fall over the gaps in between the petals of the previous layer. Stick the prepared yellow centre into the middle of the flower with sugar glue and then place it in a flower former to dry.

11 Once dry, use the flat brush to dust the edges of the petals with some dark pink powdered food colour (see below).

12 To assemble, roll a thin sausage of green gum paste to make a stem and stick on to a prepared round plaque sprayed with pearl lustre colour. Run a mini quilting tool along the stem to stitch (J).

13 Prepare several unwired ivy leaves (see pages 32–33 for instructions), then stick these and the gerbera on to the plaque, using a little royal icing, to finish.

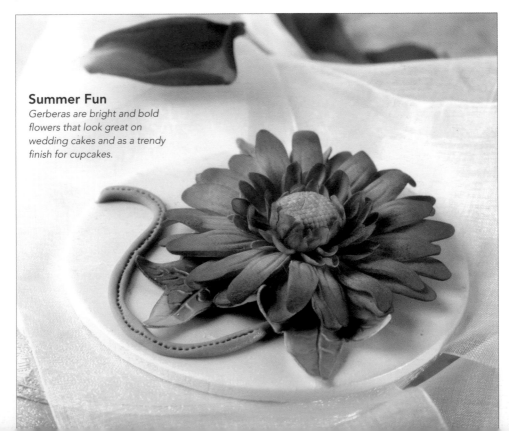

Summer Fun
Gerberas are bright and bold flowers that look great on wedding cakes and as a trendy finish for cupcakes.

Open Rose

Materials:

Gum paste: white, green, yellow

Powdered food colour: pink, yellow, green

Royal icing: white

Tools:

Rose petal cutter (largest from set of 4)

Medium rose leaf plunger cutter: 30mm (1¼in)

Daisy marguerite plunger cutter: 27mm (1in)

Paintbrush: 12mm (½in) flat

Mini modelling tool

Flower former

Mexican foam balling pad

Ball tool

A B C D

E F G H I

J

Instructions:

1 On a non-stick surface, roll out some white gum paste quite thinly. Cut out a rose petal using the largest single rose petal cutter (A).

2 Place the petal on a Mexican foam balling pad, then rub a ball or bone tool around the edge of the petal to soften and shape. Then curl the upper edges of the petal back by rolling them from the outer edge inwards with a mini modelling tool (B).

3 Flip the petal over and cup it using a large ball tool, rubbing it around in a circular motion in the centre of the petal (C). Prepare a further four petals in the same way.

4 While the petals are still soft, stick them together with sugar glue, lining the points up at the bottom and the left edge of each petal positioned about halfway across the previous one (D). Once you have all five in position, bend them around, so that you can stick the first petal to the last to complete the circle. Lay in a flower former to dry.

5 Use the daisy cutter to cut out a daisy shape from white gum paste (E).

6 Roll each of the petals from side to side with a mini modelling tool to widen and thin, then use the scissors to cut each petal of the daisy shape in half (F).

7 Take a pea-sized ball of yellow gum paste and roll it into a cone shape using the heel of your hand (G).

8 Take a small pair of scissors and repeatedly snip into the surface of the cone at the bulbous end to create the stamens. Cut off the tapered end of the cone so that the base is now flat (H).

9 To complete the stamen centre, stick the stamens into the centre of the prepared daisy shape with a little sugar glue (I).

10 Stick the prepared centre into the middle of the flower with sugar glue. Place in a flower former to dry (J).

11 Use the flat brush to colour the centre with a little yellow and green powdered food colour and the edge of the petals with pink. Arrange on an oval plaque with three rose leaves. See pages 32–33 for instructions for the rose leaves.

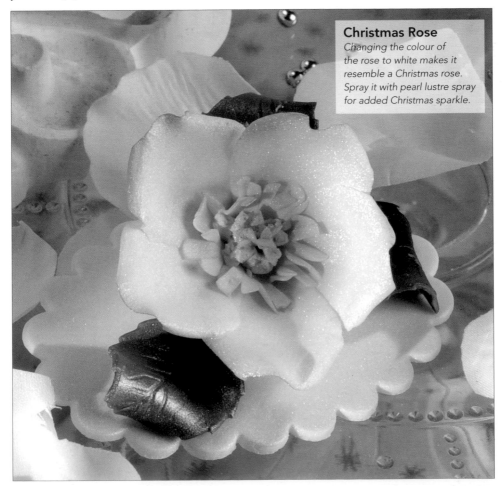

Christmas Rose
Changing the colour of the rose to white makes it resemble a Christmas rose. Spray it with pearl lustre spray for added Christmas sparkle.

Daffodil

Materials:

Royal icing: yellow, dark yellow, green, white

Tools:

Waxed paper and flower nail

Piping bag and writer tubes: ST3 and ST2

Leaf/spiked petal tube: ST54

A

B

C

D

E

F

Instructions:

Flowers

1 Place a small square of waxed paper on top of a flower nail, sticking it in place with a dot of royal icing. Take a piping bag filled with some stiff, dark yellow royal icing, and tipped with the ST3 piping tube. Hold the bag at a 90-degree angle to the flower nail. To create the trumpet, touch the centre of the flower with the tip of the tube, squeeze the bag and, while rotating the flower nail, pipe a continuous line of icing in a circle. Keep going until you have piped about four circles continuously, one on top of the other.

2 With the ST2 piping tube and dark yellow royal icing, pipe a zigzag around the top edge of the trumpet to make it look frilly. Leave to dry (A).

3 Fill a piping bag with the leaf/spiked petal tube and pale yellow royal icing with a stiff consistency. Place a small square of waxed paper on top of a flower nail, sticking it in place with a dot of royal icing.

4 Hold the flower nail in one hand and hold the piping bag with the other positioned at a 45-degree angle to the surface of the nail. Touch the tube to the surface at the centre of the nail, with the flattened 'V' of the tube uppermost. Squeeze the piping bag with constant pressure to release the icing, pulling the bag towards the outer edge of the nail and releasing the pressure on the bag as you reach the edge to break the stem of icing. You should have a petal that looks wide at the base and tapers to a point (B).

5 Turn the flower nail one third and pipe another petal, then turn another third and pipe in the final petal for this row (C).

6 Pipe the next layer of three petals in the same way, positioning these ones in between the petals on the previous layer, lifting the bag slightly higher as you do so. As soon as the petals have been piped, push the prepared dried trumpet into the centre (D). White flowers can be worked in the same way, using white royal icing (E).

Leaves

7 Leaves are piped with the same piping tube as the petals. They are best piped in place, but can be piped on to waxed paper, if required. Pipe from the base to the tip, touching the surface where you want to the leaf to start, squeezing continuously as you pull the bag along, and releasing the pressure on the bag when you reach the desired length of leaf (F).

8 Pull the waxed paper away from the dried flowers, then arrange them on top of the leaves, securing each of them in place with a little dot of royal icing.

Springtime

The flowers can also be piped directly on to a cake or plaque. I have covered a 15cm (6in) oval cake with sugarpaste (rolled fondant), which I marbled with paste food colours first. The leaves were piped on to the cake surface first then the daffodils piped directly in place, without the use of the flower nail.

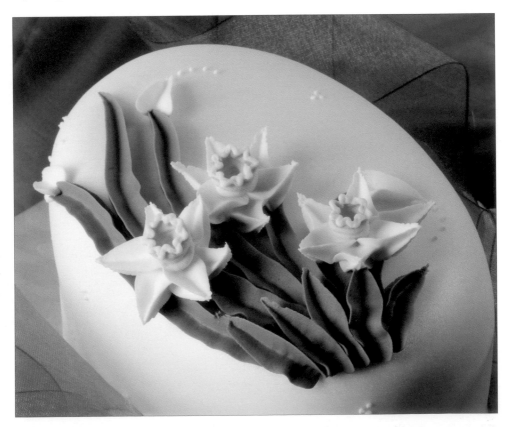

Fantasy Floral Cupcake

Materials:

Cupcake

Sugarpaste: green

Gum paste: white

Sugar pearls: blush pink

Cupcake wrapper

Lustre colour: pink, bronze

Buttercream

Tools:

Cattleya orchid cutter (throat petal only)

Round and wavy edge cutter: 75mm (3in)

Paintbrush: 12mm (½in) flat

Dresden tool

Pearl lustre spray

A

B

C

D

Instructions:

1 On a non-stick surface, roll out some white gum paste quite thinly. Cut out a petal using the throat petal cutter from a cattleya orchid set (A).

2 Vein the surface of the petal by repeatedly drawing a dresden tool across the surface from the point of the petal to the fluted edge. Now place the petal on to a greased surface and pull the soft end of a dresden tool repeatedly over the fluted edge of the petal to texture, flute and frill (B).

3 Make another petal in the same way as above. Roll the sides inwards at an angle to make a cone shape and stick with sugar glue where they overlap. Pinch the base to secure and trim off the base with a small cutting wheel to shorten. Open up the throat by inserting a bulbous cone tool into it (C).

4 Cut out a circle of green sugarpaste using a round and wavy-edged cutter. Secure to the top of a cup cake with a little buttercream. Rub your fingers around the edge of the sugarpaste to soften the cut line. Draw a dresden tool across the surface of the cupcake to mark a stem in place. Then mark a leaf shape on either side of the stem using the same tool (D).

5 Stick the smaller curled throat petal to the front of the flat throat petal with a little sugar glue, then stick this to the top of the stem on top of the cupcake. Add some sugar pearls, then paint detail on the leaves and flower using bronze and pink lustre spray. To use lustre spray to paint with, just spray into the lid and paint on to the item with a flat paintbrush. Finish with a chocolate swirl cupcake wrapper (see detail opposite).

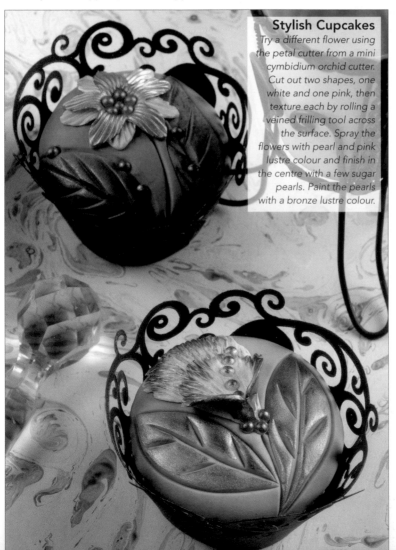

Stylish Cupcakes
Try a different flower using the petal cutter from a mini cymbidium orchid cutter. Cut out two shapes, one white and one pink, then texture each by rolling a veined frilling tool across the surface. Spray the flowers with pearl and pink lustre colour and finish in the centre with a few sugar pearls. Paint the pearls with a bronze lustre colour.

Blossoms and Buds

Materials:

Gum paste: white

Powdered food colour: yellow, pink, green

Tools:

Cone tool: taper 5, bulbous cone

Small craft scissors

28g wires: green (cut into quarter-lengths)

Small long-nosed pliers

Tiny dull round stamens: white

Paintbrushes: size 2/0 round, 12mm (½in) flat

Large oval plaque cutter: 70mm (2¾in)

A

B

C

D

E

F

G

H

I

Instructions:

1 Make a small pea-sized ball of white flower paste (A).

2 Roll the ball of flower paste on the heel of your hand to make it into a cone shape (B).

3 Flatten the top of the cone slightly with your fingers. Push a bulbous cone tool into the centre to hollow it, then insert a taper 5 point cone tool into this to divide the cone into five sections. (Dip the tool into cornflour or white fat to prevent it sticking) (C).

4 Using the small scissors, make five deep cuts into the cone, following the division lines previously marked with the tapered cone tool. This will create five equal petals (D).

5 Press your finger on the top of the cone to open out the petals. Now pinch the tops of each petal sideways to form a point (E).

6 Place your thumb on top of one of the petals and your first finger underneath and squash the petal to thin down and shape (F). Repeat for the other four petals (G).

7 Take a quarter-length of 28g green wire and bend a tiny hook at one end with the long-nosed pliers. Dip the hooked end wire into some sugar glue. Pull the wire down through the centre of the flower and secure the flower to the wire by rolling the back of the flower between your fingers (G).

8 For the first type of flower, use a mini modelling tool to roll each petal vertically from side to side to widen, thin down and shape the petals (H).

9 To complete the first type of flowers, brush the centre with some yellow petal dust, then use a flat brush to work some pale pink powdered food colour inwards from the outer edges of the petals (see detail opposite).

10 For the second type of flower, work steps 1–6, then simply insert three cotton stamens to complete (I). To finish, colour with pale pink food colouring as in step 9.

Pretty Arrangement

To make an arrangement like the one shown here, push some sugarpaste (rolled fondant) into a container. Trim the stems of the flowers and buds to size, then push the wires into the sugarpaste to arrange. For the buds, insert a 28g wire into a tiny ball of white gum paste. Twist and squash the ball on to the wire, rolling the top and bottom of the bud to taper it. Mark several lines around the sides of the bud with a dresden tool or a pair of tiny scissors. A select few ribbons will enhance the final arrangement, so have fun!

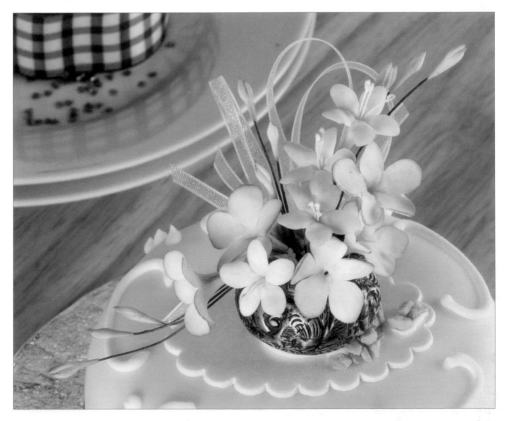

Lily of the Valley

Materials:

Gum paste: white, green

Powdered food colour:
 pink, light green, dark green

Confectioner's glaze

Tools:

28g wires: green (cut into
 quarter-lengths)

Medium blossom plunger
 cutter: 10mm (⅜in)

Lily leaf double-sided veiner

Mini cutting wheel or lily
 petal cutter

Paintbrushes: size 2/0 round,
 12mm (½in) flat

Stem tape

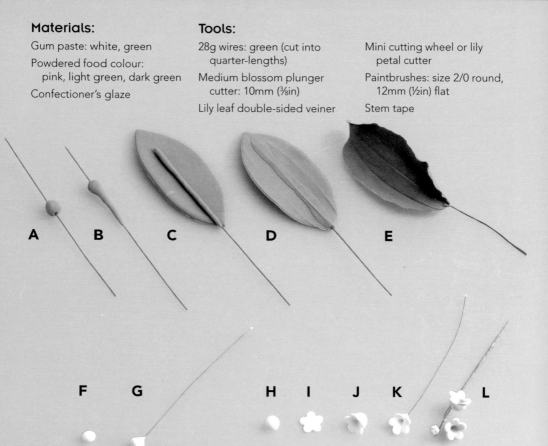

A B C D E

F G H I J K L

Instructions:

Leaves

1 Roll a pea-sized ball of green gum paste and thread it about
 30mm (1¼in) down on to a quarter-length 28g green wire (A).

2 Roll the ball between your fingers, extending it up to
 the top of the wire as you roll (B).

3 Roll out a piece of green gum paste quite thinly.
 With a mini cutting wheel, cut out a boat-shaped
 petal freehand. If you find this difficult, use a lily
 petal cutter instead and trim the base to shape.
 Lay the paste-covered end of the wire on to the
 back of the leaf (C).

4 Place the leaf inside a lily leaf veiner, then press
 down to seal the wire to the back of the leaf and
 vein the surface at the same time (D).

5 Place the leaf on to a Mexican foam modelling pad and soften the edges by rubbing a ball tool around the outer edge. Use the flat brush to colour the leaf with a little light and dark green powdered food colour. Next, place it on a piece of kitchen paper inside a cardboard cake box and spray with confectioners' glaze to set the colour and add a shine to the leaves (E).

Flowers
6 Take a small pea-sized ball of white flower paste (F).

7 Take a quarter-length of 28g green wire and bend a tiny hook at one end with the long-nosed pliers. Brush the hooked end of wire with sugar glue then pull the wire down through the bud and secure it in place by pinching the bud at the back. Use a Dresden tool to mark a cross on the top of the bud. (G).

8 Take a second small pea-sized ball of white flower paste (H).

9 Cut out a medium blossom from white gum paste (I).

10 Stick the blossom on to the top of the ball of white gum paste, using the plunger or a ball tool to push it into place (J).

11 Take a quarter-length of 28g green wire and bend a tiny hook at one end with the long-nosed pliers. Brush the hooked end of wire with sugar glue, then pull the wire down through the centre of the flower and secure it by pinching at the back (K).

12 You can leave the flowers white or use the flat paintbrush to dust them with pink food colour (see detail opposite).

13 To assemble, use stem tape to tape the buds and flowers together in long stems, starting with the buds, then add in the flowers (L).

Arrangement
Put some sugarpaste into a small container and push the stem into this to make an arrangement, placing leaves at the back and flowers at the front.

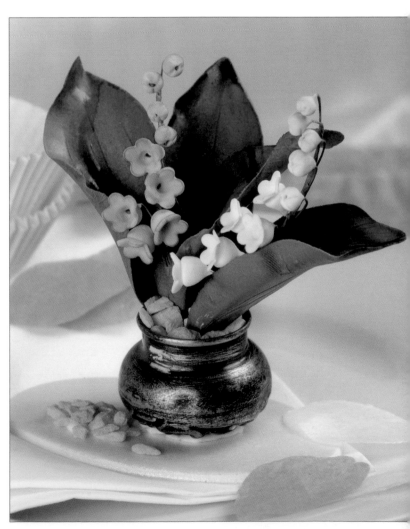

Fantasy Flowers

Materials:

Gum paste: white

Powdered food colour: blue, lilac, yellow

Royal icing: green

Tools:

28g wires: green (cut into quarter-lengths)

Small long-nosed pliers

Tiny dull round stamens: white

Five-point tapered cone tool

Meadow cranesbill cutter

Large oval plaque cutter: 70mm (2¾in)

Paintbrushes: size 2/0 round, 12mm (½in) flat

Piping bag and leaf tube: ST52

Stem tape

Pearl lustre spray with spray gun attachment

A

B

C

D

E

F

G

H

Instructions:

Single layer fantasy flower

1 Take a small pea-sized ball of white flower paste and make it into a cone by rolling the ball of flower paste on the heel of your hand (A).

2 Pinch the wide end of the cone with fingers and thumbs to flatten and widen the base, leaving the pointed end of the cone as a stem standing up in the middle (B), like a Mexican hat.

3 Roll the flattened base area with a mini modelling tool to thin and widen even more, rolling from right up close to the stem to the outside edge (C).

4 Place the meadow cranesbill cutter over the Mexican hat, then push down to cut out the flower shape as shown. Release from the cutter by pushing a ball tool into the centre of the flower (D).

5 With a mini modelling tool, roll each petal vertically from side to side to widen, thin down and shape the petals.

6 Push a five-point tapered cone tool into the centre of the flower to mark a star shape. Take a quarter-length of 28g green wire and bend a tiny hook at one end with the long-nosed pliers. Dip the hooked end of the wire into some sugar glue. Pull the wire down through the centre of the flower and secure the flower to the wire by rolling the back of the flower between your fingers (E).

Double layer fantasy flower

7 Repeat steps 1 to 6 above, but do not insert the wire at stage 6. Put the flower to one side and roll out some white gum paste. Cut out a second flower shape using the same cutter (F).

8 Roll the petals from side to side as in step 5 (G). Place on a foam pad and push a ball tool into the centre of each petal to cup them.

9 Use sugar glue to stick the new piece on top of the flower, interleaving the two sets of petals. Cut three stamens and attach them to a 28g wire with stem tape. Insert the wire and stamens into the centre of the flower, then secure the flower by rolling the paste at the back between your fingers.

10 Dust the centre of the flower with some yellow food colouring and the round brush. Use the flat brush to dust the edges of the petals from the outer edge inwards with some lilac or blue powdered food colour. Tape the flowers together with stem tape, trim the stem and then use royal icing to secure them to a fluted oval plaque sprayed with pearl lustre colour (see detail opposite).

11 To hide the stem, pipe a few green leaves over it with green royal icing using an ST52 piping tube (see page 11 for instructions for piped leaves).

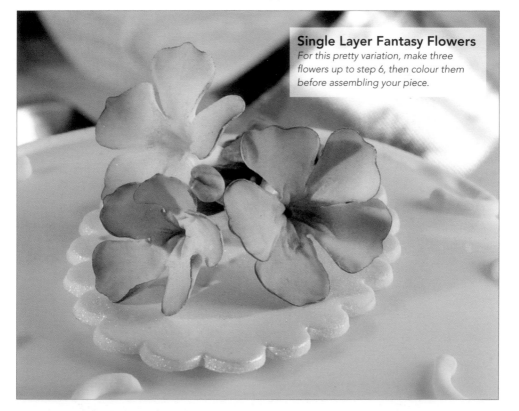

Single Layer Fantasy Flowers

For this pretty variation, make three flowers up to step 6, then colour them before assembling your piece.

Rose and Ivy Leaves

Materials:

Gum paste: green, cream

Powdered food colour:
dark green, light green,
burgundy

Tools:

28g wires: green (cut into
quarter-lengths)

Stem tape: green

Confectioners' glaze

Rose leaf plunger cutter:
25mm (1in)

Ivy leaf plunger cutters: 22mm
(⅞in), 28mm (1⅛in)

Ball tool

Instructions:

Rose leaves

1 On a non-stick surface, roll out a piece of green gum paste to
a thickness that will allow a wire to be inserted into it. Use a rose leaf
plunger cutter to cut out the shape, then push the plunger down to vein
the surface of the leaf (A).

2 Dip the end of a quarter-length 28g wire into a little sugar glue, then carefully
insert the wire into the leaf, pushing the wire three-quarters of the way up into
the leaf for support. Gently squash the paste on to the wire to secure (B).

3 Place the leaf on to a Mexican foam modelling pad, then soften the edges by rubbing a ball or bone tool around the edge of the leaf (C). Unwired leaves can be made in the same way (D); simply do not insert the wire at step 2.

4 To colour the leaves, dust all over with some light green powdered food colour, then dark green in places and just over the edge with a little burgundy.

Ivy leaves

5 Cut a small ivy leaf shape from green gum paste then place this on top of a rolled-out piece of cream gum paste (E).

6 With a small rolling pin, roll over the surface of the paste to merge the green ivy leaf shape into the cream paste (F).

7 Take the larger ivy leaf plunger cutter and cut out and vein the leaf (G).

8 Finish the leaf in the same way as the rose leaf described above (H). An optional wire (I) can be inserted at step 7.

Finishing

9 Set the colour and add a glossy finish to the leaves with confectioners' glaze, which will result in a high gloss finish. For a softer look, steam the leaves over a pan of boiling water by just waving the leaves through the steam for a very short time. Holding them in the steam for too long will result in the leaves melting and falling off the wires. Leave to dry.

10 Tape the leaves together with green stem tape.

Safety note
Steam can scald you. Take extra care when using steam to glaze leaves.

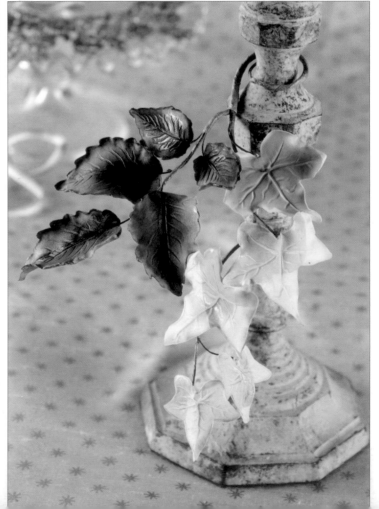

Tumbling Foliage
Achieve a natural effect by using different sized plunger cutters to make a sprig of foliage. In this example, 30mm (1¼in) and 40mm (1½in) rose leaf plunger cutters and a 15mm (1⅝in) ivy leaf plunger cutter were used in addition to the 25mm (1in) and 22mm (⅞in) cutters.

Freesia

Materials:

Gum paste: white

Powdered food colour: yellow, burgundy, green

Tools:

28g wires: green (cut into quarter-lengths)

Tiny dull round stamens: white

Freesia cutter: 35mm (1⅜in)

Paintbrushes: size 2/0 round, 12mm (½in) flat

A B C D

E F G

H I J K

Instructions:

Flowers

1 Make a Mexican hat by pinching the wide end of a cone of gum paste with your fingers and thumbs. This flattens and widens the base, leaving the pointed end of the cone as a stem standing up in the middle. Roll the flattened base area with a mini modelling tool to thin and widen even more, rolling from right up close to the stem to the outside edge (A).

2 Place the freesia cutter over the Mexican hat, push down and cut out the flower shape. Release from the cutter by pushing a ball tool into the centre of the flower. With a mini modelling tool, roll each petal vertically from side to side to widen, thin down and shape. Place on foam pad and soften the edges of the petals, then cup with a ball tool (B).

3 Roll out some white gum paste and cut out a freesia petal (C).

4 Prepare petals as described in step 2 (D).

5 Attach a thin piece of stem tape to the end of a 28g wire. Lay six stamens in place on the tape against the wire (E).

6 Bind the stamens to the end of the wire by winding the stem tape securely around them, continuing down the wire to the base (F).

7 With sugar glue, stick the flat petals on top of the Mexican hat petals, interleaving the petals. Brush a little sugar glue on to the wire at the base of the stamens. Insert wire and stamens into centre of the flower, secure by rolling paste at the back of the flower between fingers. With a small pair of scissors held at a 45 degree angle to the base of the stem, make a tiny cut into the paste on either side of the stem to create a small calyx (G).

8 Use the size 2/0 round brush to colour the centre of the white flowers with some yellow petal dust and leave the petals white. For the burgundy flowers, brush the outer edges of the petals from the stem upwards with some burgundy powdered food colour and a flat brush (see detail opposite). Dust the calyx with green.

Fragrant Freesias
Always a popular choice for brides, these sugar flowers look great on their own or combined with other bridal flowers.

Buds

9 Insert a 28g wire into a large pea-sized ball of white gum paste (H).

10 Use your fingers to roll the paste at the base of the ball to thin it down and secure it to the wire (I).

11 Roll the top of the bud to taper slightly, then cut a calyx in place at the base of the flower with a pair of small scissors (J).

12 With fingers, push the top of the bud over to the side a little and mark lines with a pair of scissors (K).

13 To complete, colour the buds with some green powdered food colour using the flat brush. The smaller buds should be totally green and the larger buds should be green just at the base over the calyx. Dust the tips of the buds with the colour to match the flower.

14 Tape the buds and flowers together in a long stem using stem tape, starting with smallest buds and finishing with the flowers.

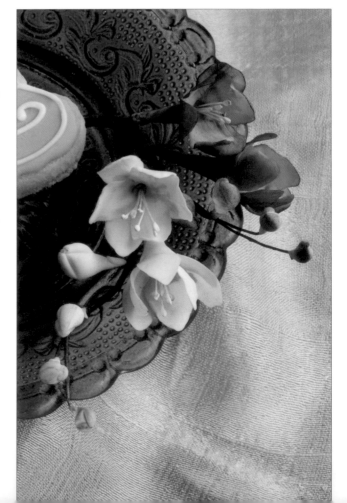

Materials:

Gum paste: pale green, pale yellow

Powdered food colour: pale green, pink, yellow,

Liquid food colour: burgundy

Tools:

28g wires: green (cut into quarter-lengths)

Stem tape: green

Medium mini cymbidium cutter

Paintbrushes: size 2/0 round, 12mm (½in) flat

Flower/leaf shaper tool

Mexican foam balling pad

Cone tool

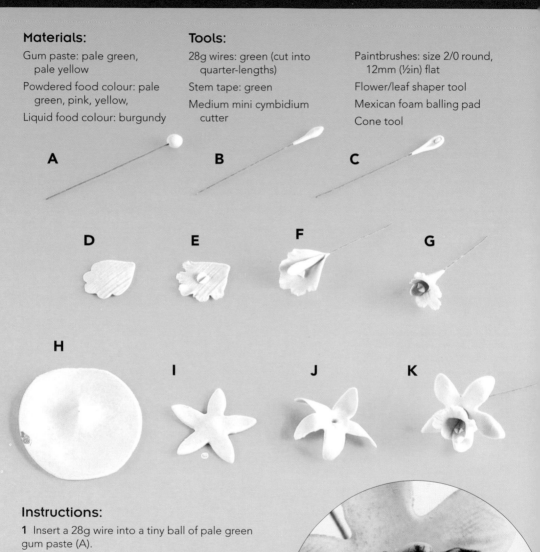

Instructions:

1 Insert a 28g wire into a tiny ball of pale green gum paste (A).

2 Roll the paste between your fingers to make a small bud shape (B).

3 Hollow the underside of the bud using a ball tool. Stick a tiny ball of paste into the hollow and divide it in half with a flower/leaf shaper tool (C).

4 On a non-stick surface, roll out some gum paste quite thinly and cut out a throat petal (D).

5 Lightly vein the surface from tip to frilled edge by drawing a dresden tool across the surface. Stick a tiny ball of paste in the centre, dividing it in half as before. Place the flower on to a Mexican foam pad and soften the edge with a ball tool (E).

6 Lay the bud on the throat petal with the hollow of the bud facing down against the throat petal (F).

7 Paint the straight edges of the throat petal with sugar glue and secure the petal around the bud. Push a ball tool in between the bud and the petal to open up the throat (G). Leave to dry.

8 Take a ball of light green paste and pinch to a flat rounded shape leaving a thicker part in the middle. With a mini modelling tool roll the paste away from the centre, leaving a small thicker area in the middle, but pressing down the rest of the paste until it is quite thin (H).

9 Centralise the petal cutter over the bump and cut out petals (I).

10 Place the petals on to a foam pad. Run a ball tool around the edges of all the petals then pull the ball tool down four of the petals from tip to base to cup the petals backwards. Flip petals over and cup the remaining one petal forwards. Make a small indent in the centre of the flower with a bulbous cone tool (J).

11 Paint a little sugar glue around the base of the throat petal then thread the wire down through the centre of the petals positioning the petals so that one petal cups forwards over the top of the throat and the others cup backwards. Pinch the bump at the back of the flower to secure to the wire (K).

12 Brush a little yellow and pale green powdered food colour on to the petals and into the throat, a little pink over the edge of the throat and tips of the petals. Paint stripes and spots on the edge of the throat petal with burgundy liquid colour using the size 2/0 paintbrush. Tape the flowers together with green stem tape.

Mini Cymbidiums
These delightful orchids come in many different colours. They look great on their own or mixed in with other flowers, such as roses.

Carnation

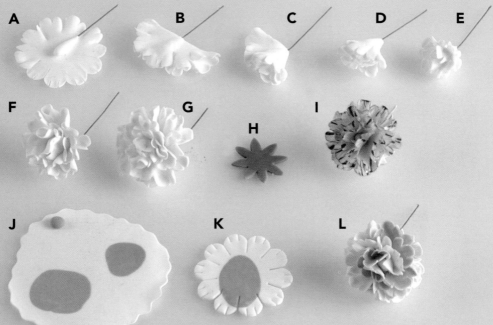

Materials:

Gum paste: white, green, pink

Powdered food colour: pink

Tools:

Carnation cutter: 35mm (1⅜in)

Small daisy cutter

26g wires: green (cut into quarter-lengths)

Paintbrushes: size 2/0 round, 12mm (½in) flat

Mexican foam balling pad

Instructions:

Striped flowers

1 With gum paste, form a bud shape on the end of a hooked 26g wire on a non-stick surface, roll out some white gum paste quite thinly and cut out a carnation shape using the largest cutter. Lay a mini modelling tool on the edge of the petals and roll backwards and forwards to frill and flute. Ensure you use plenty of cornflour to stop the paste and tools from sticking (A).

2 Thread the wired bud down through the centre of the prepared petal. Paint a little sugar glue on one half of the petal, fold the petal in half and squash it securely over the bud (B).

3 Now divide the petal into thirds. Paint sugar glue over the middle third and fold the third on the right side up and across the petal at a 45-degree angle (C).

4 Flip the flower over and do the same on the other side (D).

5 Squash the petals around the base of the flower to secure (E). Leave to dry.

6 Prepare two more petals in the same way as the first. Thread the wire down through the middle of the second layer of petals and squash the petals in place behind the first petal using sugar glue to stick (F).

7 Thread the wire down through the middle of the third layer of petals and squash the petals in place behind the second layer of petals, using sugar glue to stick (G).

8 From green gum paste, cut out two small daisy shapes. Soften the edges with a ball tool on a Mexican foam pad, then thread them up one at a time on to the wire before sticking it behind the flower. Leave to dry (H).

9 Mix a little pink paste food colour with white alcohol, and use the round brush to paint lots of little stripes over the edges of the petals (I).

Pink variegated flowers
10 Take a ball of pink paste, place it on a flattened piece of white paste and roll with a small rolling pin to blend the colours together (J).

11 Cut out a carnation shape and prepare it as detailed in step 1 (K).

12 Prepare two more petals and prepare the flower as described above in steps 2–8. Once dry dust the edges with a little pink powdered food colour (L).

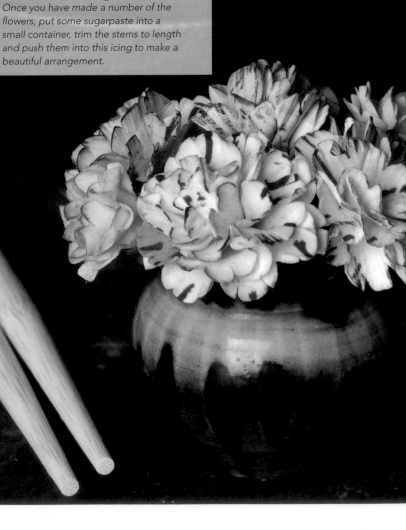

Carnation Arrangement
Once you have made a number of the flowers, put some sugarpaste into a small container, trim the stems to length and push them into this icing to make a beautiful arrangement.

Rose

Materials:

Gum paste: white, ivory, green

Powdered food colour: yellow, green

Paintbrushes: size 2/0 round, 12mm (½in)

Tools:

Extremely large five-petal blossom cutter: 75mm (3in)

Extremely large calyx cutter: 60mm (2⅜in)

20g wires: green (cut into quarter-lengths)

Paintbrushes: size 2/0 round, 12mm (½in) flat

Stem tape: green

Mexican foam balling pad

Ball or bone tool

Dresden tool

Instructions:

1 With long-nosed pliers, bend a hook on the end of a 20g wire. Roll a small marble-sized ball of white paste, moisten the hook with sugar glue, then pull the wire down through the centre of the ball of paste (A).

2 With your fingers, roll the top of the ball of paste to form a pointed cone shape. Leave to dry (B).

3 On a non-stick surface, roll out some ivory gum paste quite thinly. Cut out a five-petal blossom shape using the extremely large cutter. Place the shape on a Mexican foam balling pad

then soften and shape the edges of the petals by rubbing a ball or bone tool around the outer edge of each petal (C).

4 Use a round paintbrush to paint the centre of the blossom shape with sugar glue. Pull the wired cone down through the centre of the flower and stick one petal tightly around the cone (D).

5 Select a pair of petals opposite one another, and apply sugar glue three-quarters of the way up the sides of the petals. Stick each petal in turn to the side of the cone, starting with the right-hand side of each petal, then sticking the left-hand side of each petal down so that it overlaps the edge of the opposite petal (E).

6 Select the remaining two petals and stick around the bud in the same way as before, spiralling the petals around. This forms the bud stage of a rose. Roll a tiny ball of green paste, thread on to the wire and stick it at the base of the rose (F).

7 To make a medium-sized rose, cut out and prepare another set of petals, this time cupping each petal with a ball tool. Thread them on to the wire and move them behind the bud. Glue each petal on in turn so that they spiral around, with the right-hand side of each petal stuck down first, and the left-hand side of each subsequent petal overlapping the previous one (H). Add a green ball of paste as before.

8 Cut out a calyx shape from green gum paste (G), place it on a foam pad and soften the edges with a ball tool. Moisten it with sugar glue and stick it to the base of the rose, using a dresden tool to tuck the paste in around the little green ball of paste that was previously added to the base of the flower (H).

9 A larger rose can be achieved by adding a further set of petals in the same way before adding on the calyx (I).

10 Once dry, use a flat brush to dust the edges and down in between some of the petals with a little yellow powdered food colour (see detail opposite) and add in a little green colouring. Assemble by taping the stems together with stem tape adding in some rose leaves (see pages 32–33 for instructions on how to make the rose leaves).

Elegant Roses

Additional curl can be added to the top edges of the rose petals by rolling them backwards with a mini modelling tool. Secure to a sugar plaque with royal icing for a beautiful cake topper.

Orchid

Materials:

Gum paste: white

Powdered food colour: yellow, green, pink, burgundy

Liquid food colour: burgundy

Tools:

26g wire: white (cut into quarter-lengths)

Cattleya orchid cutter

Stem tape: green

Paintbrushes: size 2/0 round, 12mm (½in) flat

Dresden tool

Ball tool

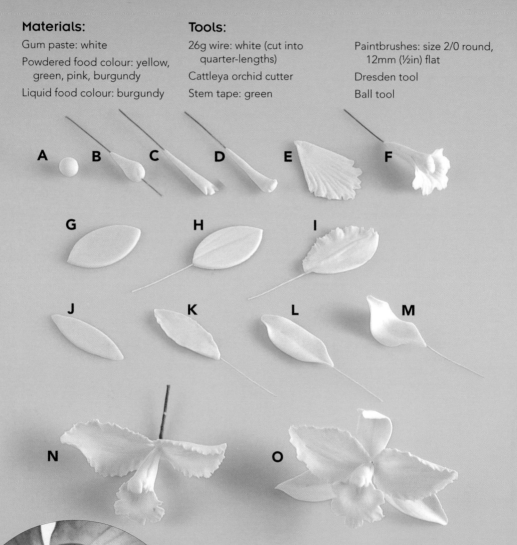

Instructions:

1 Roll a piece of white gum paste into a large pea-sized ball (A).

2 Roll the paste with your fingers to elongate it along the wire and to shape it into a long slim bud shape (B).

3 Flatten the end of the bud then divide the end into three, making two small cuts with a pair of scissors (C). Pinch the outer two sections flat, then bend them over at the sides (D).

4 Hollow out the underside of the bud with a ball tool. Stick a tiny ball of paste into the hollow and divide in half with a dresden tool.

5 Cut out a throat petal and place on a greased non-stick board. Lightly vein with a dresden tool, flute the scalloped edge by pulling the soft end of the flower leaf shaper tool repeatedly over the edge (E).

6 Stick the throat petal around the bud, with the hollow of the bud facing down inside the throat (F).

7 Roll out a piece of gum paste, to a thickness that will allow a 26g white wire to be inserted into it and cut out two wide petals (G). Place in a plastic food bag until ready to use.

8 Carefully insert a wire into the base of each of the wider petals, pushing the wire three-quarters of the way up into the petal for support. Gently squash the paste on to the wire to secure (H).

9 Place the petal on to a foam pad and use the sharp end of a flower/leaf shaper tool to mark a vein down the middle of each one. Then use the soft end of the tool to flute the edge as described before for the throat petal. Gently pinch the base of the petals together and dry the petals over a gentle curve (I). These will be the 'arms'.

10 Cut out the three narrow petals of the same thickness as in step 7 (J).

11 Prepare the thin petals as described in steps 8–9, but run a ball tool around the edges to soften, rather than fluting the edges (K).

12 Take two narrow petals. Gently pinch each at the base then dry over a soft curve to make the 'legs' (L).

13 Take the last narrow petal, pinch the base and then bend it into an 'S' shape for the 'head' (M).

14 Once dry, use stem tape to attach the side petals (arms) around the throat petal (N).

15 Attach the bottom petals (the legs) and finally the top petal (the head) which should cup forwards over the top of the throat petal (O).

16 Use the flat brush to add a little yellow and pale green powdered food colour into the centre of the throat petal, a little pink over the edge of the throat and all over the petals. Add darker areas to the edges of the petals with burgundy. Paint small stripes and spots on the edge of the throat petal with burgundy liquid colour and the size 2/0 round brush (see detail opposite).

Exotic Orchids

These beautiful orchids come in many different colour combinations. Be brave, have fun and experiment with colour.

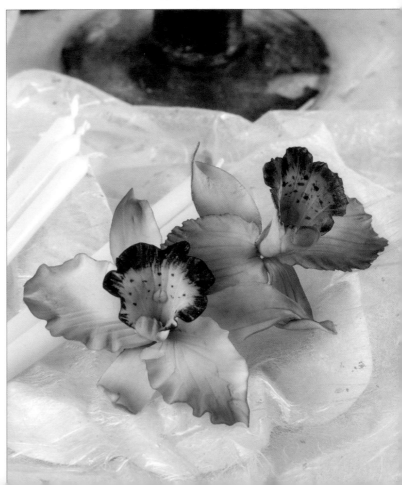

Lily

Materials:

Gum paste: ivory, green

Powdered food colour: yellow, light green, dark green, pink, burgundy

Liquid food colour: burgundy

Tools:

26g wire: white (cut into quarter-lengths)

Small veined lily plunger cutter: 60mm (2⅜in)

Stem tape: green

Paintbrushes: size 2/0 round, 12mm (½in) flat

Dresden tool

Ball tool

Instructions:

1 To make the pistil, roll a piece of green gum paste into a large pea-sized ball and push down on to a 26g wire (A).

2 Roll the paste with your fingers to elongate it along the wire and to shape it into a long slim bud shape, narrower at the base and wider at the top (B).

3 Flatten the end of the bud then divide the end into three, marking the divisions with a dresden tool. Add a small ball of green paste at the base and pinch three equally spaced ridges vertically around it. Dust all over with light green petal dust and a little burgundy on the very top. Brush the top with glaze (C).

4 Gather together six ready-made lily stamens (D).

5 Colour them with yellow and burgundy petal dusts before taping the stamens around the base of the pistil with some stem tape.

6 Roll out a piece of gum paste, to a thickness that will allow a 26g white wire to be inserted into it, then cut out and emboss three wide (F) and three narrow petals (G). Place them in a plastic food bag to keep them soft until you are ready to use them.

7 Carefully insert a wire into the base of each of the petals, pushing the wire three-quarters of the way up into the petal for support. Gently squash the paste on to the wire to secure.

8 Place the petals on to a foam pad and rub a ball tool around the edge of the petals to soften, thin and shape each one. With a pair of small fine-nosed scissors, snip into the paste at the base of the petals to create fine hairs. Bend the wire within the petals to a soft curve and dry over a gentle curve, such as a small rolling pin (H and I).

9 To colour, use the flat brush to add a little yellow and pale green powdered food colour at the bottom of each petal (see detail opposite). Dust the whole of the centre of each petal with dark pink and burgundy, leaving a white outer edge. Paint the hairs and some tiny spots at the base of the petals with burgundy liquid colour using the size 2/0 paintbrush (J).

10 Once dry use stem tape to secure the three wide petals together around the pistil before securing the three narrow petals immediately behind and in between the first three.

11 The flowers can be steamed to set the colour if required. See steps 9 and 10 on page 33 for details of steaming.

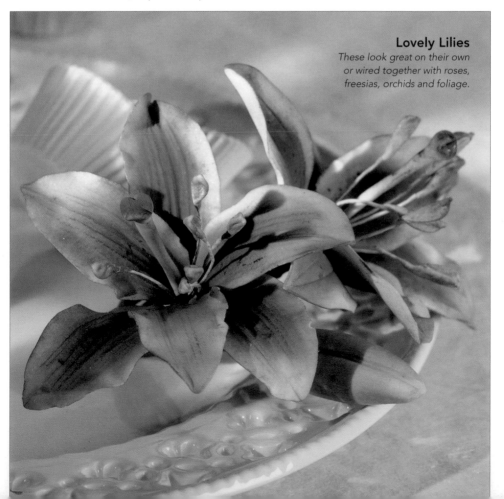

Lovely Lilies
These look great on their own or wired together with roses, freesias, orchids and foliage.

Butterflies

Materials:

Gum paste: white

Powdered food colour: yellow, blue, pink, green

Paste food colour: brown

Cardboard

Tools:

26g and 24g wire: gold

Butterfly plunger cutters: 30mm (1¼in), 45mm (1¾in) and 60mm (2⅜in)

Piping tube: ST2

Paintbrushes: size 2/0 round, 12mm (½in) flat

Tiny dull round stamens: white

A B C D E F G

H I

J K L

Instructions:

Body

1 Insert a wire into a small ball of white gum paste (A).

2 With fingers twist and shape paste on to the wire to form a bud shape (B).

3 Push two small cotton stamens in to the end of the bud shape for the antennae (C).

Wings

4 On a non-stick surface, roll out some white gum paste quite thinly. Cut out a butterfly with the smallest butterfly plunger

cutter and push the plunger down to emboss the surface of the icing and then again to expel the icing from the cutter (D).

5 Roll the edge of the wings with a mini modelling tool to flute and frill (E).

6 For wired butterflies, stick the bodies to the centre of the wings with a little sugar glue (F).

7 Dry the butterflies on some flat foam for flat butterflies. For butterflies with raised wings, prepare a concertina of cardboard to use as a former, and place the butterflies in the former to dry (G).

Broderie Anglaise butterflies
8 Cut out the butterfly, but do not emboss the surface. Use a broiderie anglaise flower cutter to emboss the surface instead (H).

9 Roll the edges of the wings to flute and frill as before. Use the end of a number ST2 piping tube to cut out small holes along the edge of the wings (I).

Colouring
10 Once dry, dust the butterflies with powdered food colours. Start by dusting the centre of the butterfly with yellow (always use the lightest colours first) (J).

11 Select a contrasting darker colour (I have used blue) and dust over the edges of the wings from the outside edge in towards the centre, blending the colours where they meet (K).

12 Using the embossed lines as a guide, paint the finer detail in place with the size 2/0 round paintbrush and dark brown paste colour mixed with white alcohol (L).

13 To assemble, either wire the butterflies into a spray of flowers with stem tape or insert a posy spike into a cake and fill it with a little sugarpaste. Push the wires into this to arrange the butterflies.

Safety note
For health and safety reasons, never insert wires directly into a cake. A posy spike is always required.

Magical Butterflies
For a fantasy look, spray the butterflies with pearl lustre spray and add edible glitter. Always add the lustre colour last, as painting on top of lustre colour will cause the lines to bleed.

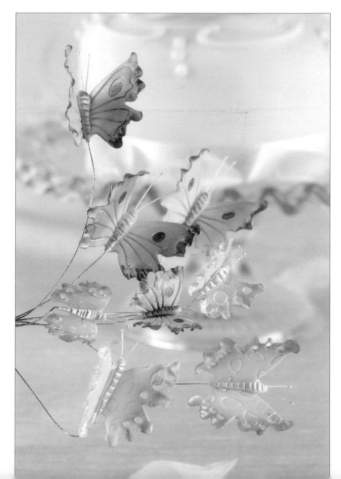

Acknowledgements

The author would like to thank the talented team at Search Press, especially Roz for commissioning this title, Edd for his superb editorial skills and Juan, Marrianne and Debbie for designing and creating the fantastic photographs.

With special thanks to Pat, David and Shailesh at Knightsbridge PME Ltd, for supplying the majority of the tools and equipment used to create the projects in this book.

Publishers' Note

If you would like more books on sugarcraft, try the following:
Sugar Animals by Frances McNaughton, Search Press, 2009
Sugar Fairies by Frances McNaughton, Search Press, 2010
Decorated Cookies by Lisa Slatter, Search Press, 2010

You are invited to visit the author's website:
www.celebrationcreationsbylisa.co.uk